The Beginner's Guide to
Chinese Painting

Birds and Insects

by Mei Ruo

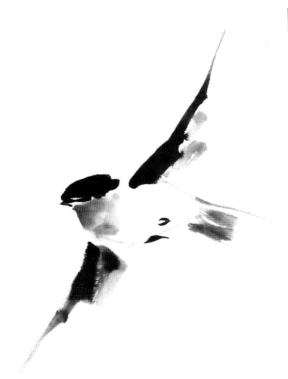

Better Link Press

This book is edited and designed by the Editorial Committee of *Cultural China* series.

Managing Directors: Wang Youbu, Xu Naiqing
Editorial Director: Wu Ying
Editor (Chinese): Shen Xunli
Editor (English): Zhang Yicong
Editorial Assistants: Jiang Junyan, Abigail Hundley

Text by Mei Ruo

Translation by Yawtsong Lee

Interior and Cover Design: Yuan Yinchang, Li Jing

ISBN: 978-1-60220-108-8

Address any comments about *The Beginner's Guide to Chinese Painting: Birds and Insects* to:

Better Link Press
99 Park Ave
New York, NY 10016
USA
or
Shanghai Press and Publishing Development Co., Ltd.
F 7 Donghu Road, Shanghai, China (200031)
Email: comments_betterlinkpress@hotmail.com

Printed in China by Shanghai Donnelley Printing Co., Ltd.

3 5 7 9 10 8 6 4

Contents

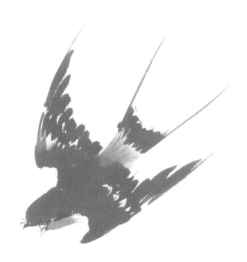

Preface

Birds and insects are an indispensable part of the flora and fauna of our planet; many of them have got along well with humankind and have played a very important part in Chinese painting.

In the "flower and bird" genre of Chinese painting, mastery of the techniques of bird painting is essential.

All birds are physically egg-shaped. Start from an egg form in its characteristic perspective, add the head, neck, wings, tail, legs and feet to the appropriate spots of the ovoid and you have a basic painting of a bird.

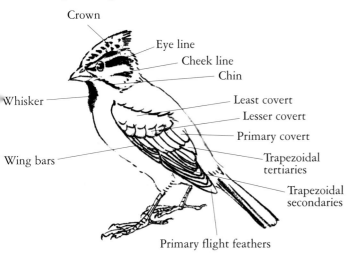

The fully deployed wing of a bird consists of two parts: the fan-shaped primary flight feathers and the trapezoidal secondaries. Bird flight is largely dependent on the wing feathers; they are functionally more complex than the plumage on its back. The bird wing consists of the wingtip,

the alulae, the primary and lesser coverts and the primary and secondary flight feathers; the closer the feathers are to the body the smaller they are. An important principle in the *xie yi* ("writing-of-ideas", minimalist, suggestive) style of flower-and-bird painting is to avoid overdoing a brush stroke if one single stroke of the brush can do the job. When painting birds, the body language of the bird must be accurately captured; select the poses and the body angles with an artist's eye toward enhancing the esthetics of the painting. A well executed tail is essential to a vivid portrayal of a bird.

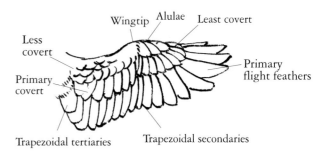

Most mountain birds have long tails and short beaks, and waterfowl possess shorter tails and longer beaks. Birds inhabiting forests and mountainous habitats have more colorful plumage than those in deserts, whose feathers tend to be grayish. The *xie yi* style of painting allows a degree of exaggeration in rendering birds with pronounced characteristics. Practice in sketching birds from life helps mastery of the basic anatomy of the bird.

Painting a *Si mao* stroke

A basic technique in bird painting employs the *si mao* (feather-edging) stroke: first the brush is pressed open in the palette (i.e., with the direction of the brush unchanged), it is rotated in a squirming fashion, and then the flattened brush is lifted in the opposite direction and pressed down lightly, returning to the upright position. With the brush tipped with thick ink, the feather-edging should have a radiating look. Note the variation in shape and size and the progression from darker to lighter ink tones. The edge of the wing should have a smooth and even finish. It is a good idea to outline the upper edge of the wing as a starting line for feather-edging to avoid a "disheveled" look.

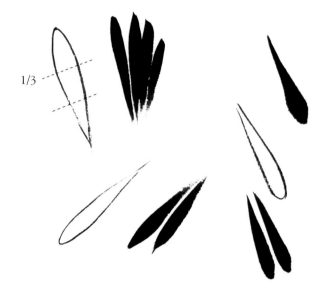

Painting a feather

Start with centered-tip stroke at the one third mark of the feather, entering the stroke by slightly pressing down on the brush; exit the stroke by gradually lifting the brush. A lot of practice is required to acquire the ability to paint a feather in one stroke of the brush.

Painting *Cao chong* (grass insects)

Cao chong painting is a sub-genre in the genre of flower-and-bird painting. Its subjects include crustaceans, mollusks, reptiles, amphibians and fishes. *Cao chong* are tiny but structurally complex animals. It is not easy to do justice to them in a vivid portrayal. Besides consulting books on relevant techniques and imitating the fine works of flower-and-bird artists, the learner must assiduously practice drawing from life. Only when the learner has acquired a feel for the physical shape, anatomy, colors, dynamics, habits and characteristics of these animals will he/she be better equipped to face the challenges in the process of painting these animals.

In the *xie yi* style of *cao chong* painting, the pictorial composition, colors, strokes and ink use should be kept simple. Focus should be on just a few essential physical components. Basically the artist is expected to paint one component in one clean-cut stroke without revisiting or being bothered with trivial details. The main thing is to communicate the lively spirit of the animal.

Sparrow

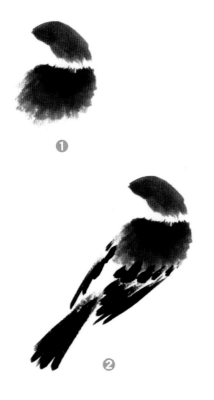

The traditional sequence in bird painting is the beak, the eyes, the head, the body, the wings, the tail, the breast feathers, followed by the legs and feet.

To paint a sparrow, begin with the beak (which is wider than some other birds'), then add the eyes, the head (in ocher), the body (with ink-tipped brush), the wings (in ink), the tail, the breast feathers (in light ink), the feet (in dark ink), finishing up by outlining in dark ink the throat feathers and dotting its back.

This approach is not always very effective for a vivid portrayal of a bird. Once the learner gets the hang of it, he/she could choose to paint the body first, then the head. This approach is better at portraying the bird in its various poses.

Painting a sparrow

1. With a brush dipped in ocher and tipped with ink, feather-edge the body, the head; paint the wings with the brush held vertically and pressed down, and then the tail (Figures 1-2).

2. Add feet; outline the chin and the eyes in dark ink and add black dots to the back (Fig. 3).

3. Add another flying sparrow and plants (Figures 4-7).

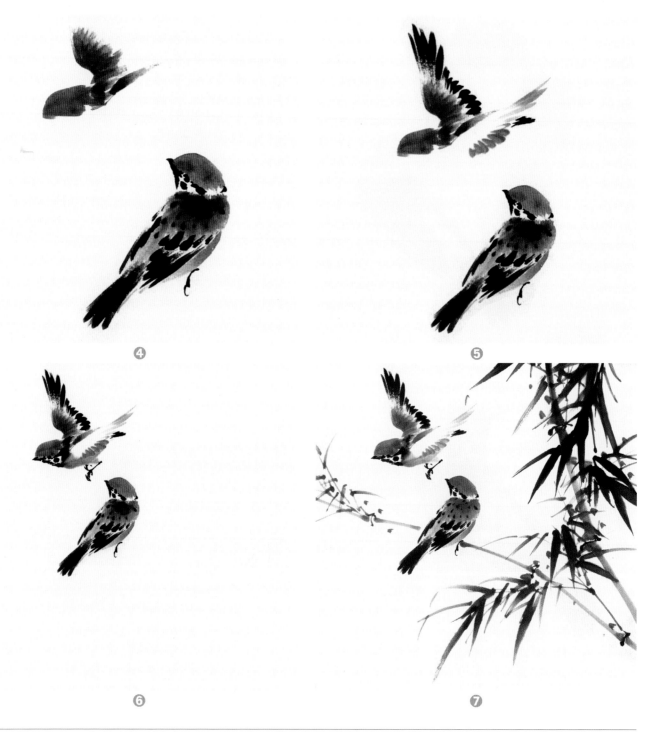

④

⑤

⑥

⑦

You can almost infinitely vary the posture of a bird simply by changing the angle and orientation of its head and its tail.

Painting sparrows in nine distinct postures

1. Paint nine egg shapes in a mixture of ocher and ink (Fig. 1).

2. Then create nine different postures without modifying the body shape (Figures 2-6).

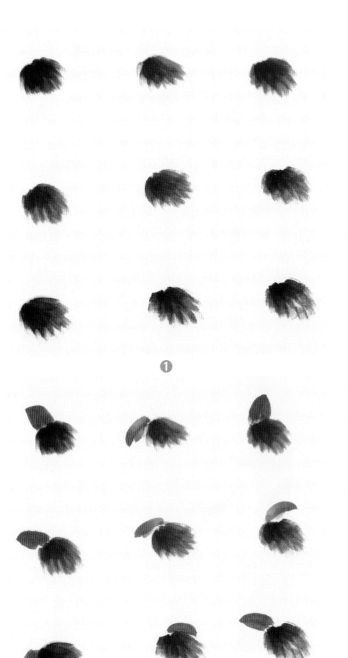

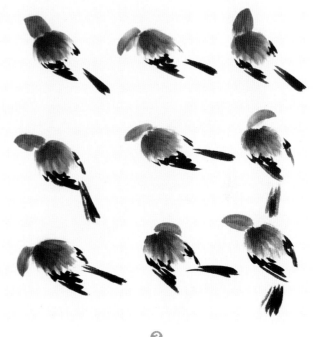

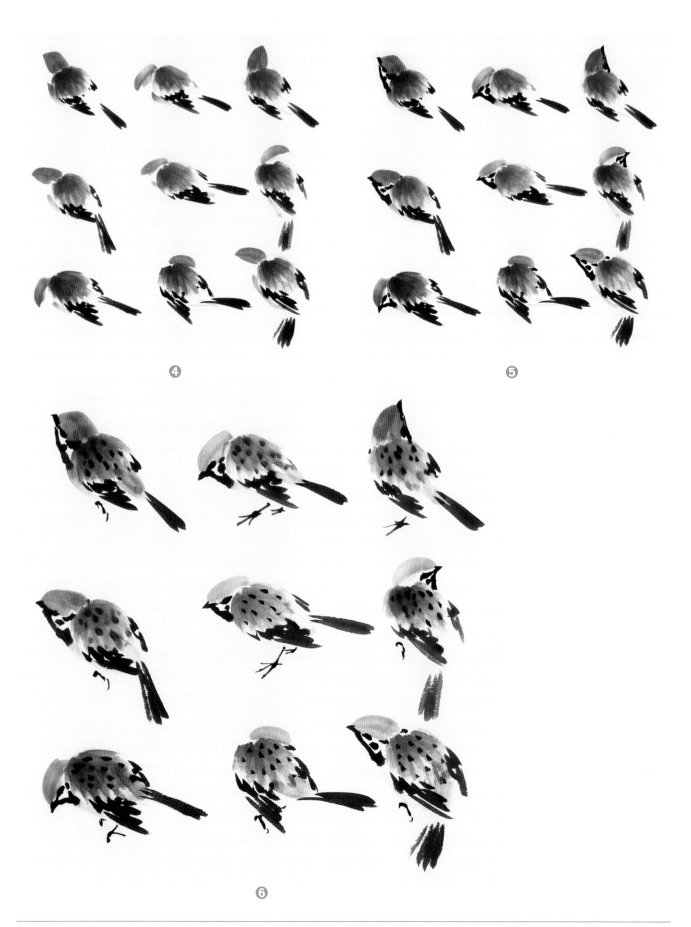

④

⑤

⑥

Painting a frontal sparrow

1. First paint the bough, and then the breast, the back and the crown in light ink (Fig. 1).

2. Once the posture of the bird is decided, add the tail, the head and the feet in turn (Figures 2-4).

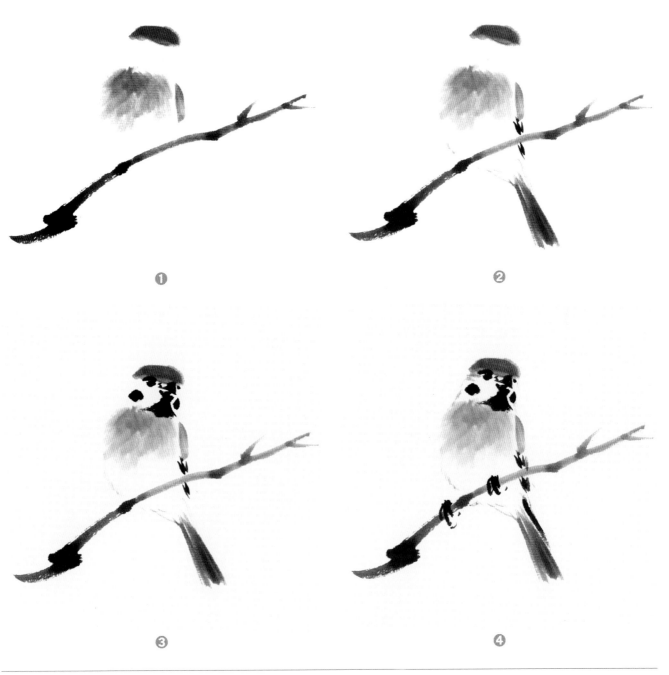

❶

❷

❸

❹

Magpie

In Chinese painting 喜鹊 *xi que* (magpie) is often shown perched on the 梅花 *mei hua* (plum tree) to signify good auspices. This is based on a play on words (homophones): 喜 *xi* means joy and as a homophone of 梅, 眉 *mei* means eyebrow, both appearing in the popular Chinese expression " 喜上眉梢 *xi shang mei shao*," meaning "joy leaping to the eyebrows" in reaction to good fortune.

The magpie has a black head, a long neck and tail. Two white patches on its shoulder contrast with the black wings and tail. It is white from the breast down to its belly. Its flight feathers are black on the upside and white on the underside. In sunlight, the magpie's body appears iridescent.

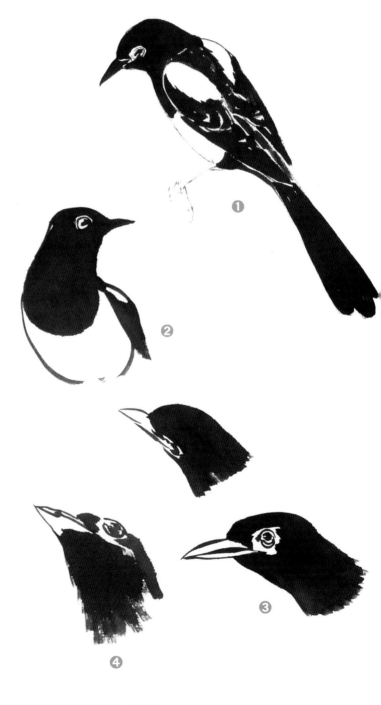

Basic technique

1. Note that parts of its head and back as well as its wings, tail and throat feathers are black. Also observe the variation in ink tone (Figures 1-2).

2. The magpie has a long beak; when outlining the beak, make sure the lines vary in thickness (Fig. 3).

3. The throat and breast feathers should also be painted in gradations of ink tone (Fig. 4).

Painting magpies

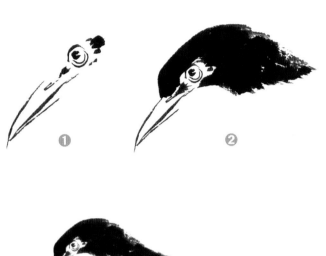

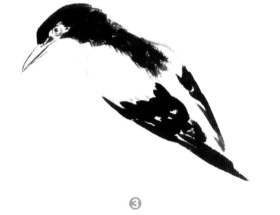

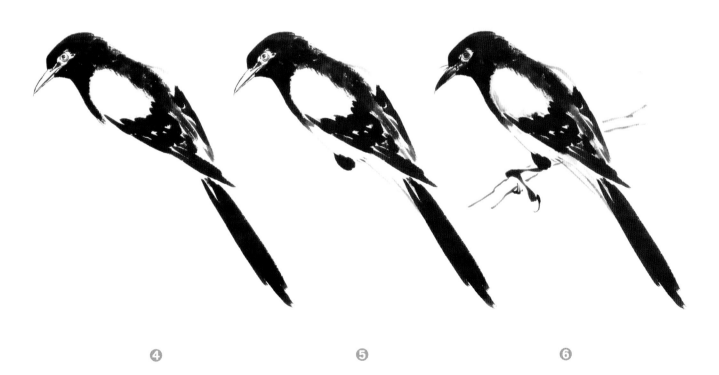

1. Outline the beak in dark ink; the line where the upper and lower halves of the beak meet must be longer than the other two lines (Fig. 1).

2. Paint the eye; paint the head by feather-edging, leaving a tiny spot bare of ink around the eye (Figures 1-2).

3. Outline the wing in light ink; feather-edge the back in dark ink. Paint the wing feathers, the coverts and the flight feathers in dark ink (Fig. 3).

4. Complete the tail in two strokes. Paint the throat and breast in dark ink; outline the abdomen in light ink (Fig. 4).

5. The leg should be thicker at the two ends and thinner in between; press and grind when entering the stroke, lessening the pressure as the stroke progresses and pressing and grinding when exiting the stroke; outline the claws in dark ink (Figures 5-6).

7. Try painting magpies in different postures
(Figures 7-10).

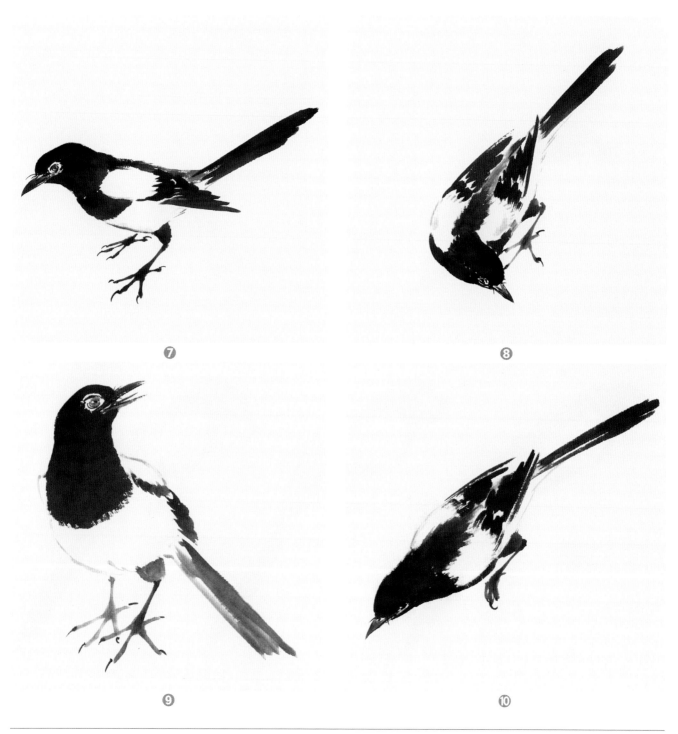

⓻

⓼

⓽

⓾

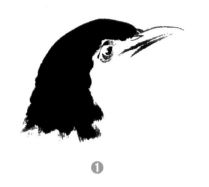

Example of a magpie painting

The magpie perched on a blossoming plum tree is a favorite subject in Chinese painting (Figures 1-11).

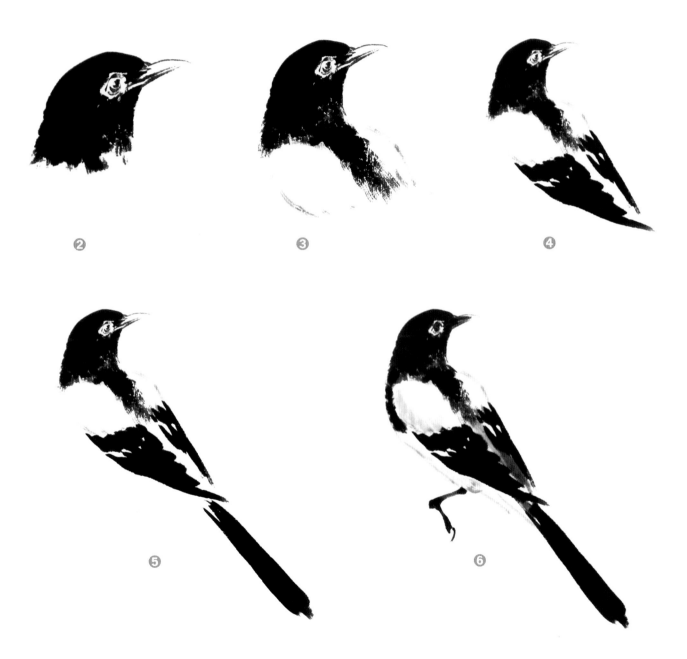

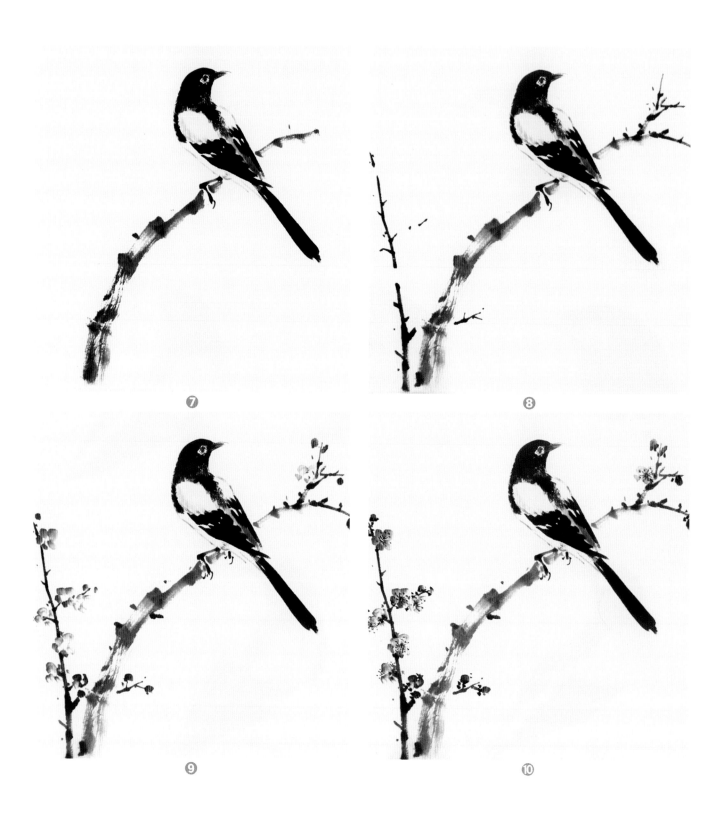

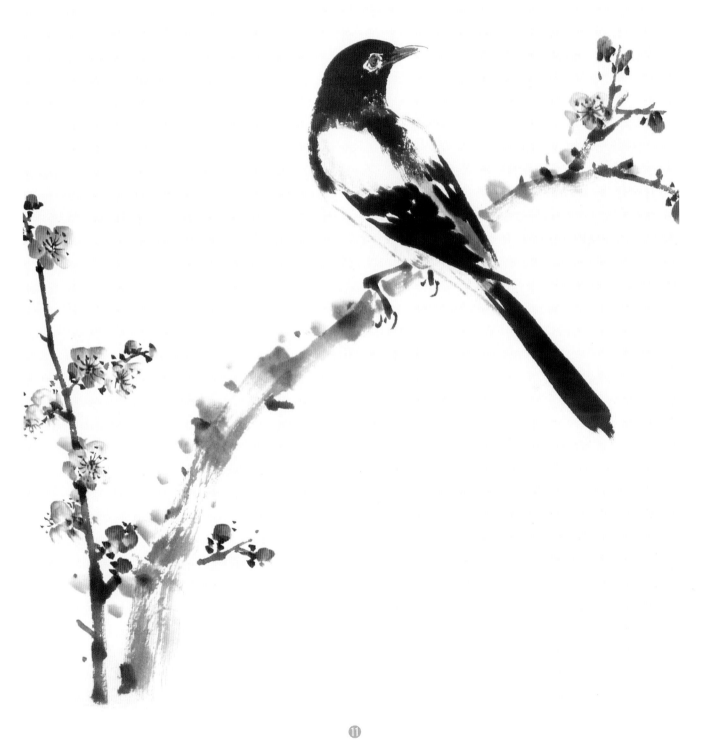

Kingfisher

The basic features of a kingfisher's head are a crest, eyestripes, check stripes, chin stripes (Fig. 1).

Fish are the main part of a kingfisher's diet. It has a long bill and a blue crest; the stripes around its eyes are deep set (the front part being brown going into black and back part all black). It has a green body and ocher breast. One of its characteristics is its short body compared to a head of almost equal length. With a short tail and short legs, it gives the impression of a disproportionately large head and a small body (Fig. 2).

The center of gravity of the bird's body has a lot to do with the placement of the legs. If the legs are placed along the center line of the bird's body, the bird will not look unsteady but will appear on a firm footing.

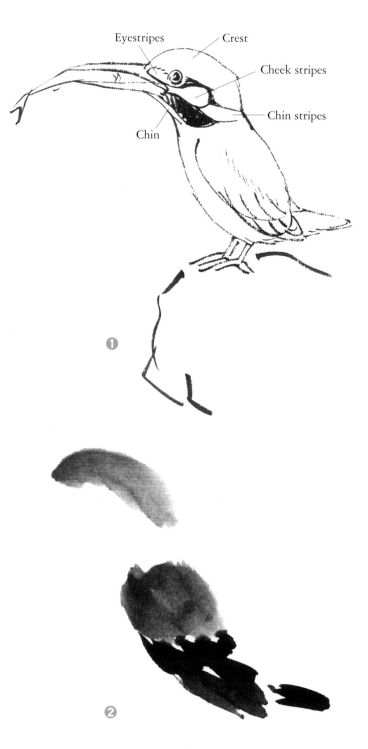

Eyestripes Crest

Cheek stripes

Chin stripes

Chin

❶

❷

① **②**

Painting a kingfisher in two ways

There are two methods of painting the kingfisher in the Chinese tradition. In one method the artist paints in light ink first before overlaying it with beryl blue and malachite green; the other method consists of applying the blue and green pigments directly.

Method I: by light ink first

1. Paint the bill first with the lines varying in thickness and the upper jaw protruding over the lower. Paint the eye in light ink (Fig. 1).

2. Use medium-shade ink to paint the crown, and paint the chin in dark ink (Fig. 2).

3. Feather-edge the back in light ink; dot the flight feathers, the coverts and the tail in dark ink (Figures 3-4).

4. Feather-edge the breast with a brush dipped in gamboge and tipped with orange red (Fig. 5).

③

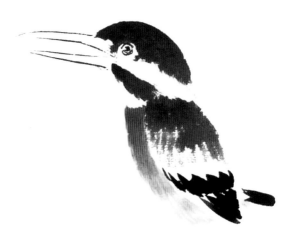

④ **⑤**

5. Paint the legs with orange red mixed with a small amount of eosin; dot the claws in dark ink. After the ink dries, fill in with various other colors: the bill in ink mixed with red, the cheek in ocher and the chin in white, the crest in beryl blue and the back in malachite green (or number two green mixed with gamboge). With the addition of a few stripes in beryl blue mixed with white on the crested head, the kingfisher is complete (Figures 6-12).

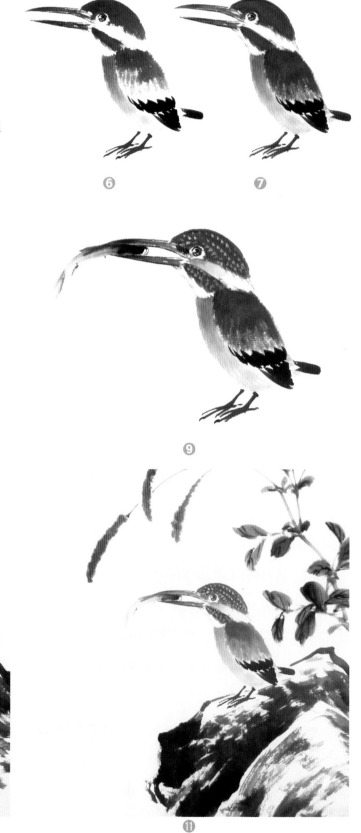

⑥

⑦

⑧

⑨

⑩

⑪

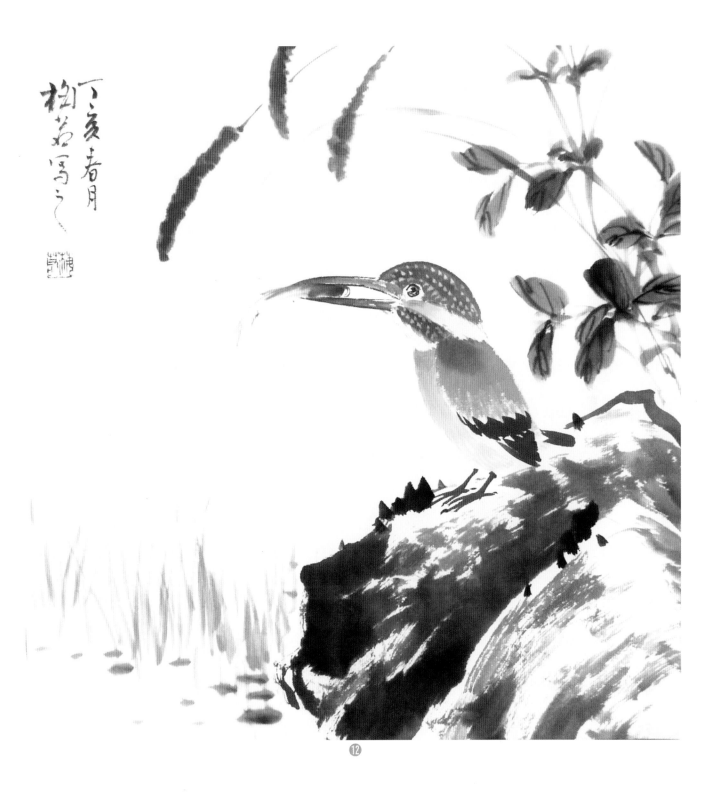

Method II: by a direct application of colors

1. Paint the head, the cheek stripe in beryl blue.

2. Paint the back with a brush dipped in olive green and tipped with number three green; paint the wing in dark ink; paint the breast with a mixture of gamboge and orange red (Fig. 1).

3. Paint the chin in white, the cheek in gamboge, the stripes on the crest in white powder mixed with beryl blue, and the legs in eosin. Add rocks and plants (Figures 2-6).

❶ ❷

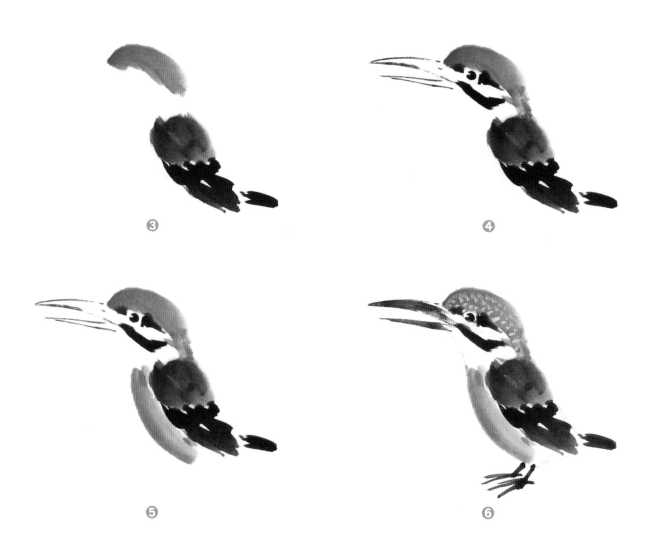

❸ ❹

❺ ❻

Example of kingfishers in various postures

(Figures 1-4)

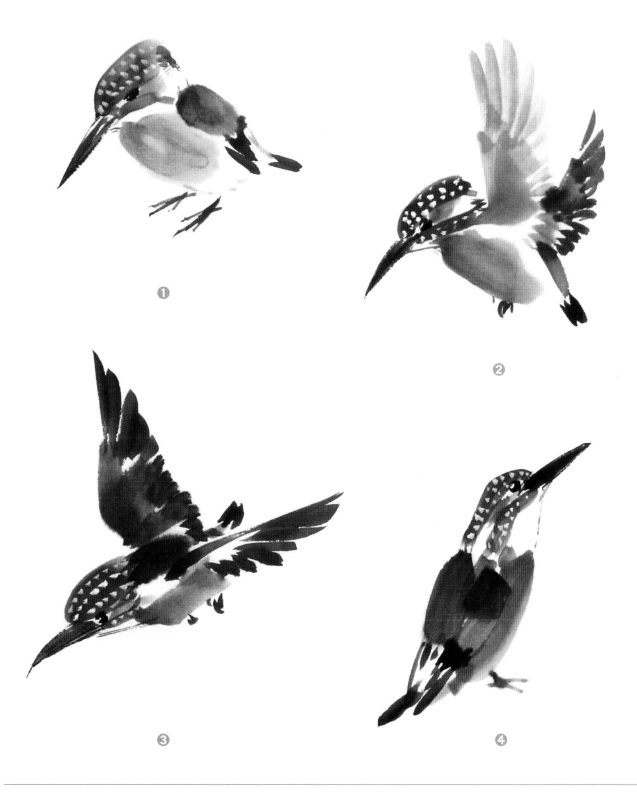

Swallow

The swallow has a short, broad beak. Its head is black all the way to its jaw. Its broad beak is ringed by down; its bill, when opened, is like a trumpet and ideal for sucking in food. It has long wings and a scissors-shaped tail (Fig. 1).

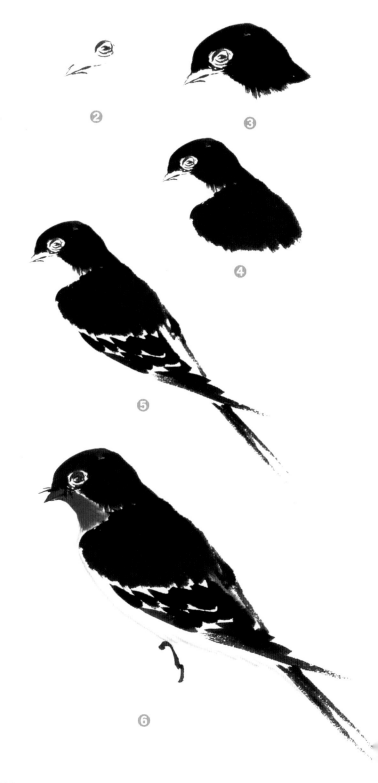

Basic technique

1. Paint the bill and the eyes first (Fig. 2).
2. Dot the head in dark ink (Fig. 3).
3. Paint the black back by feather-edging with a brush dipped in dark ink (nuance the shades of ink) (Fig. 4).
4. Paint the wings and the tail in dark ink (Fig. 5).
5. Paint the belly (it should be gray but is generally painted white for accent), the chin in orange red mixed with eosin, the legs and claws in cyanine. The black bird often gives off a blue tint in sunlight; it is therefore a good idea to touch up with number two blue at various spots on the body (Fig. 6).

Painting a swallow with its back toward the viewer

1. Paint the head and back in dark ink (Figures 1-2).

2. Paint the coverts and the flight feathers; the two lines making up the swallow tail should be forceful (Fig. 3).

3. When painting the bill, garnish it with a few downy hairs; dot the tail in ocher and paint the chin in orange red (Fig. 4).

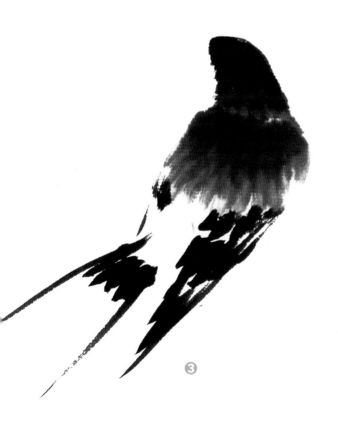

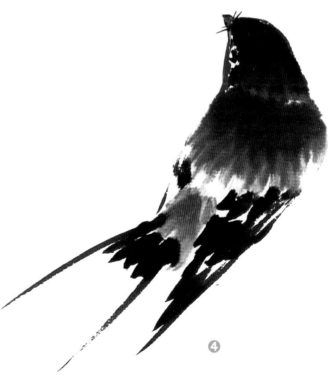

Painting
a frontal swallow

1. Feather-edge the breast feathers in light ink (Fig. 1).

2. Outline the abdomen and paint the back in dark ink (Figures 2-3).

3. Paint the chin in orange red and the bill and the head in dark ink (Figures 4-5).

4. Paint the legs on the perch, and then add the tail (Fig. 6).

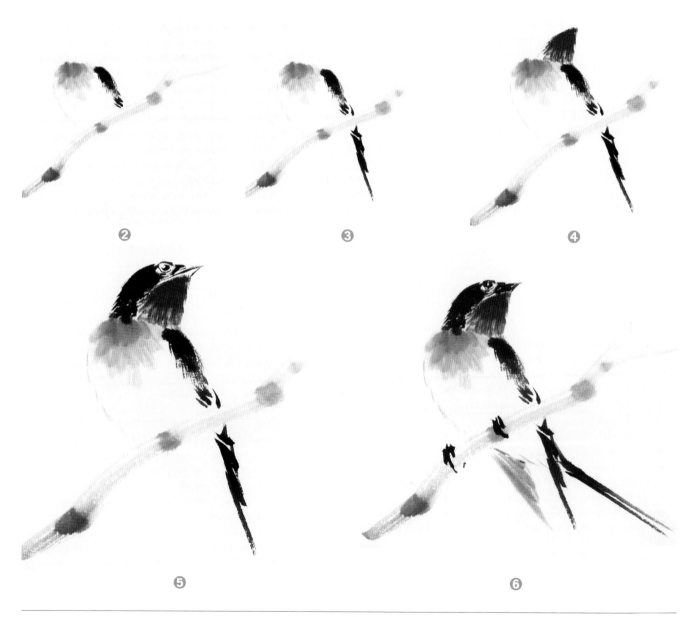

Painting a swallow in flight

1. Dot the head with a brush tipped in dark ink (Fig. 1).

2. Feather-edge the feathers on the back; paint the spread wings and the tail. Paint the wings and the tail confidently and forcefully (Figures 2-4).

3. Paint the bill in cyanine, the chin in orange red, and dot the tail in ocher. Pay attention to variation in ink shades (Fig. 5).

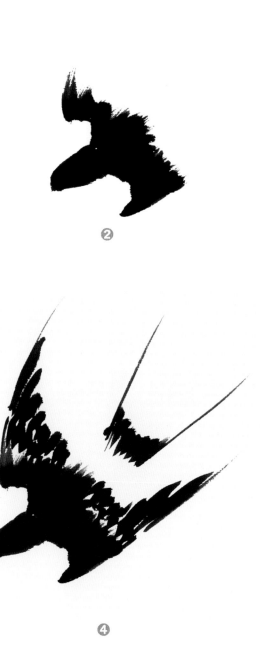

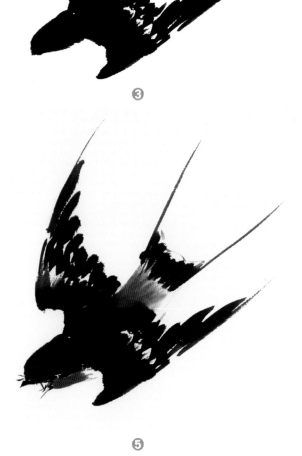

Painting a swallow
in the *xie yi* style (Figures 1-6)

Xie yi, literally "writing ideas", is an important
style in Chinese painting characterized by a free
flowing, spontaneous minimalism.

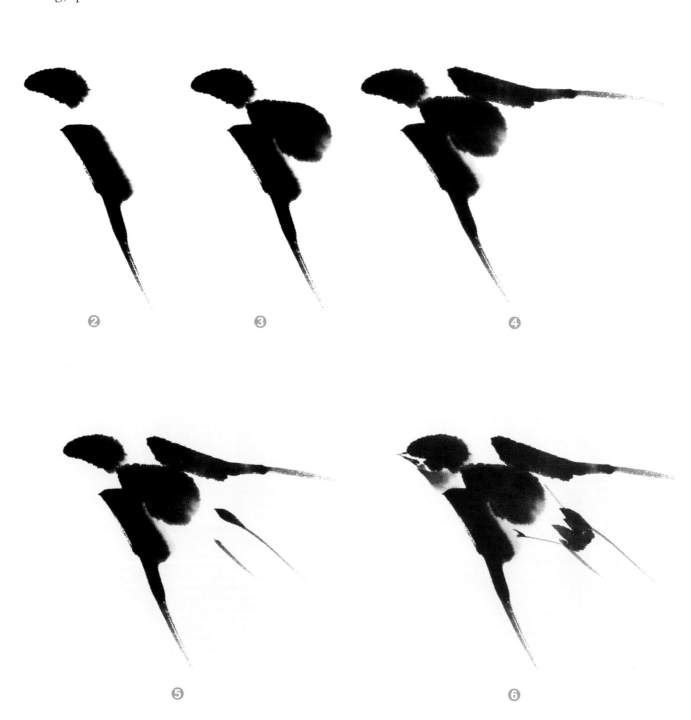

Examples of swallows in various postures (Figures 1-6)

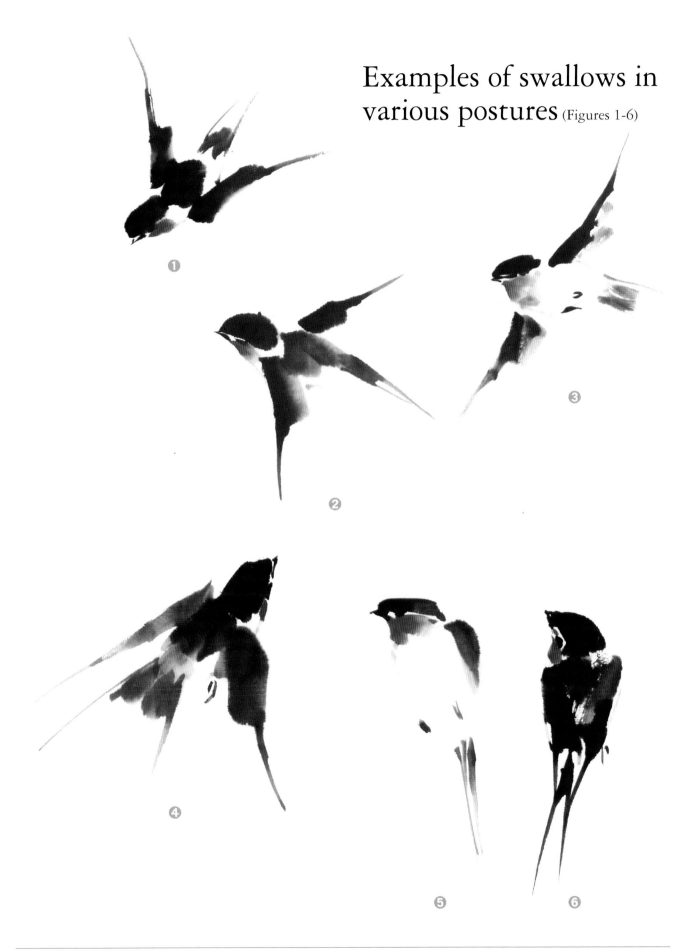

Fish

While there are many species of fish, they all are composed of the head, the body and the tail. They all have a dorsal fin, pectoral fins, pelvic fins, an anal fin and a caudal fin, a caudal peduncle and lateral lines (Fig. 1).

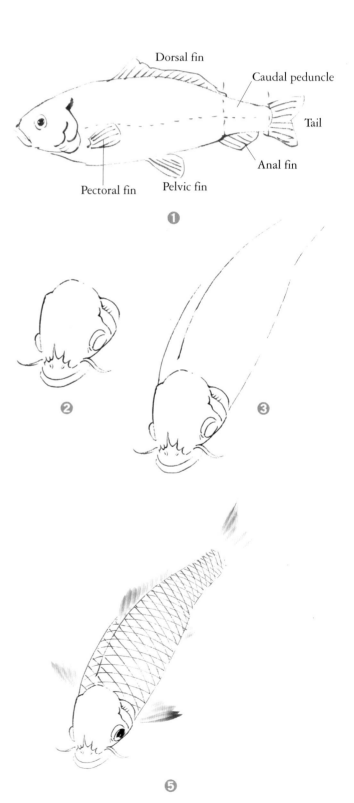

Painting a carp with a method combining the *xie yi* and the elaborate styles

1. Outline the head, eyes, mouth and barbels in ink, then outline the spine and the belly; paint the five fins in light ink (Figures 2-4).

2. Outline the scales in light ink (Fig. 5).

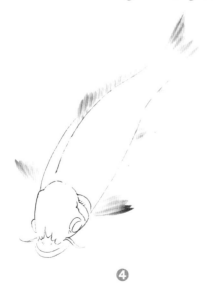

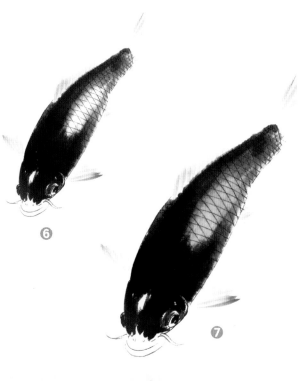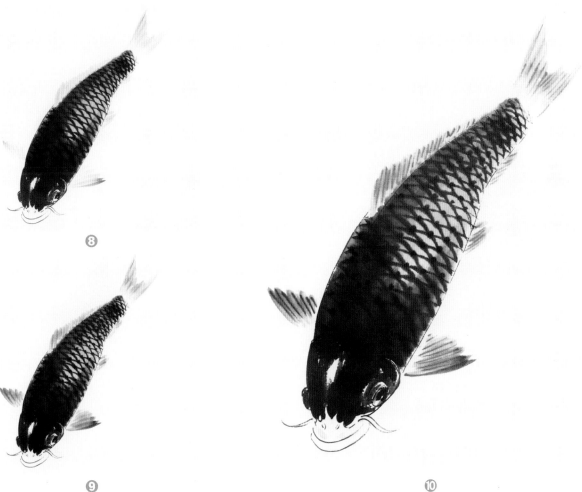

3. Apply colors after the ink dries. Paint the head in centered-tip strokes, with the brush dipped in water and tipped with dark ink, leaving a highlight in the middle (Fig. 6).

4. Paint from the spinal ridge outward toward the two sides, leaving highlights; add gamboge with the tip of the brush to the highlight spots; the ink shade should lighten toward the tail (Fig. 7).

5. With the brush tipped with dark ink, draw arcs to paint the scales, then add black dots at the intersections of the arcs; the ink shade should also become lighter toward the tail (Figures 8-9).

6. Touch up the fins with ocher; line the eyes with yellowish olive green and outline the cartilage on the fins in medium dark ink (Fig. 10).

This technique is more elaborate and laborious.

Painting carps in the *xie yi* style

1. Paint the bullet-shaped head with a brush tipped with dark ink (Figures 1-2).

2. Paint the back in side-brush strokes in dark ink, leaving highlights (Fig. 3).

3. Outline and paint the belly and the fins as well as the mouth, gills, eyes and barbels in light ink; line the eyes with a mixture of gamboge and orange red (Figures 4-6).

4. On the partially dry body, outline the scales in neat arcs with a brush dipped in dark ink (Fig. 7).

5. Render the detail of the fins in light ink (Fig.7).

To paint a red carp, follow the technique described above, but in orange red mixed with eosin (Figures 8-12).

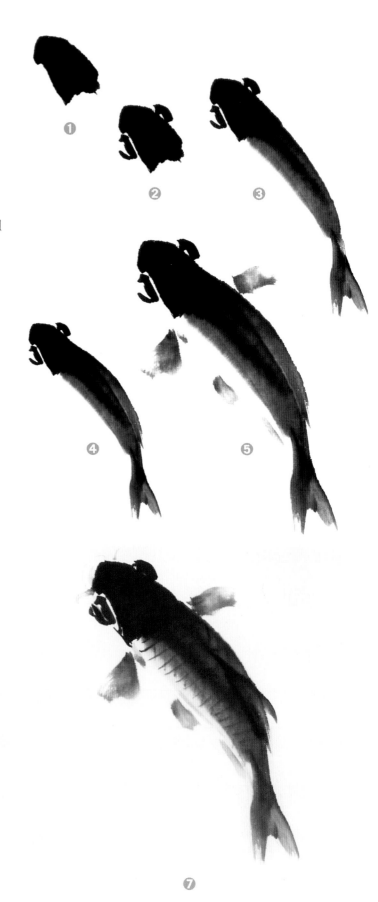

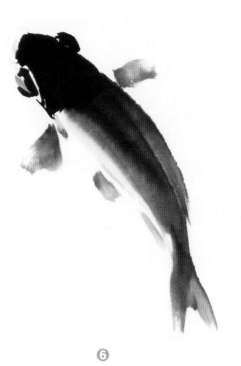

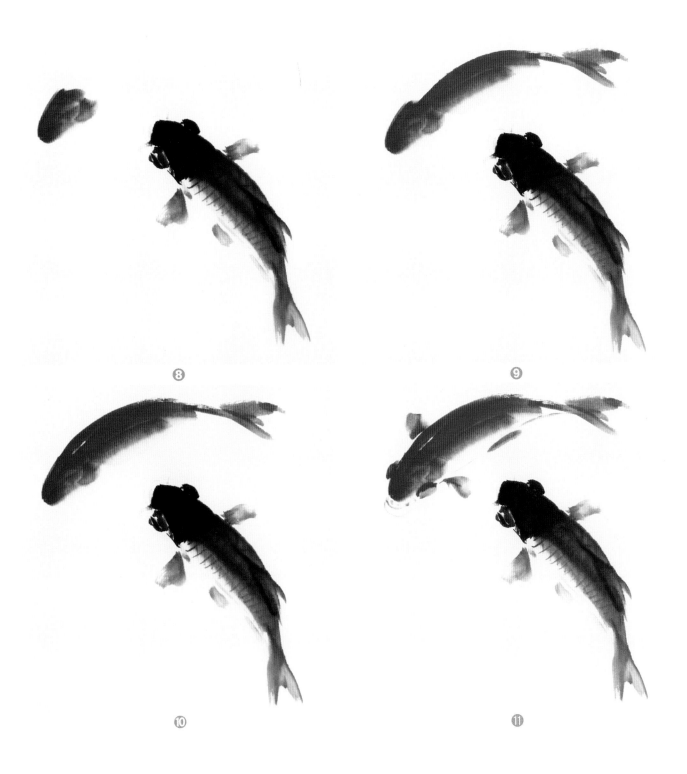

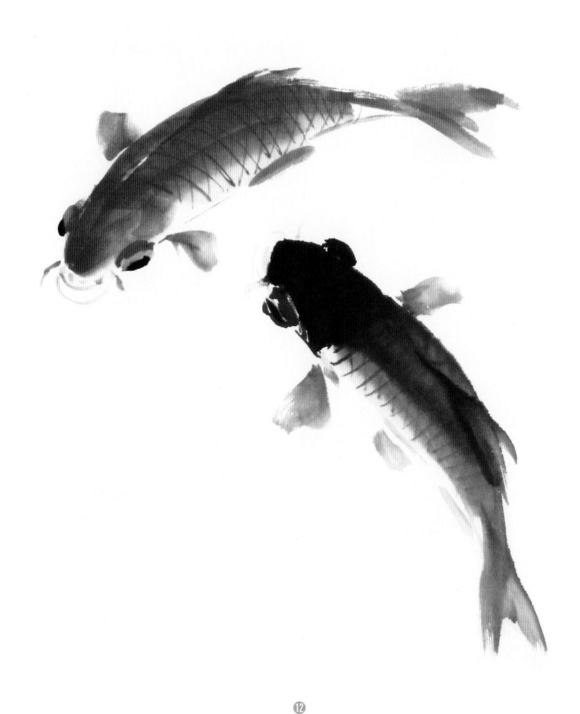

Example of a leaping carp in the *xie yi* style (Figures 1-5)

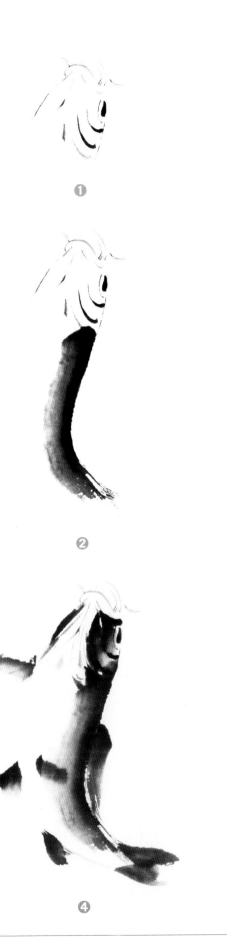

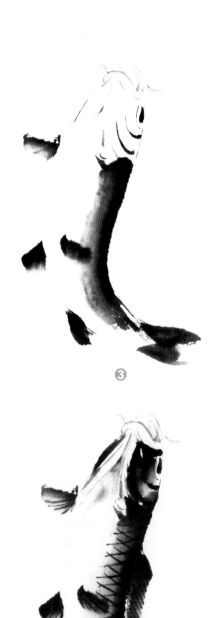

Example of carp in various postures (Fig. 6)

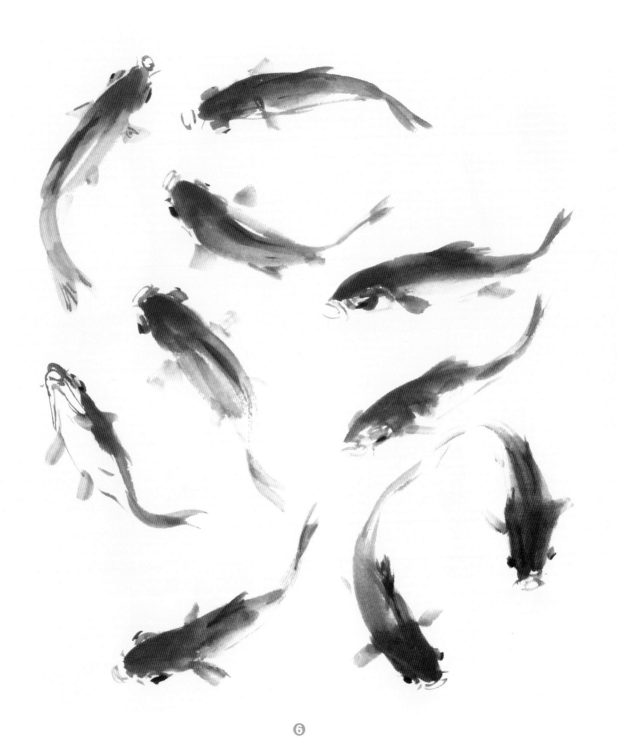

The goldfish are popular as ornamental fish. They come in a wide variety and many colors. Some examples are the pearlscale goldfish, the dragon-eyes, the red oranda, and the red-crowned oranda. Goldfish and carp have different body shapes but are structurally similar. Goldfish have dorsal, pectoral, pelvic, anal and double tail fins (Fig. 1).

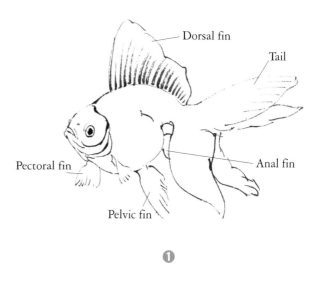

②

③

④

⑤

Dorsal fin

Tail

Pectoral fin

Anal fin

Pelvic fin

❶

Painting goldfish in the combined elaborate and *xie yi* style

1. Outline the head and body in dark ink; paint the fins in light ink (Figures 2-3).

2. Dot the scales with a brush soaked in clear water and dipped in dark ink, slightly curving the strokes (Figures 4-5).

3. Touch up the fins with ocher; on the partially dry body, touch up the scales a second time, and apply white to the belly (Fig. 6).

⑥

Painting a dragon-eye goldfish in the *xie yi* style

Ink or orange red is generally used. The steps are as follows:

1. Dot the head and the eyes with a brush tipped with dark ink (Fig. 1).

2. Paint the spinal ridge, the caudal peduncle and the tail (Fig. 2).

3. Dip the brush, by now running out of ink, in clear water to paint the belly and the fins in thus diluted ink; line the eyes with a mixture of gamboge and orange red; dot the eyes in dark ink (as the Chinese like to say: dot the eyes to make the dragon leap out of the painting!) (Figures 3-5).

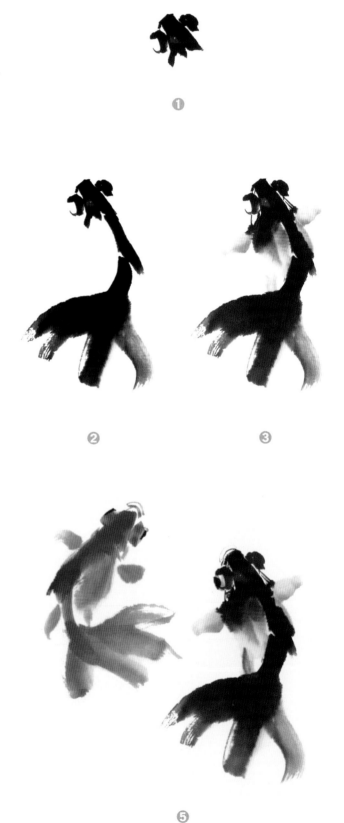

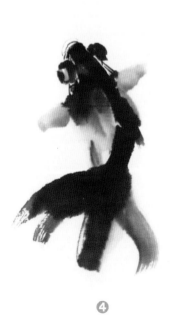

Painting a red goldfish

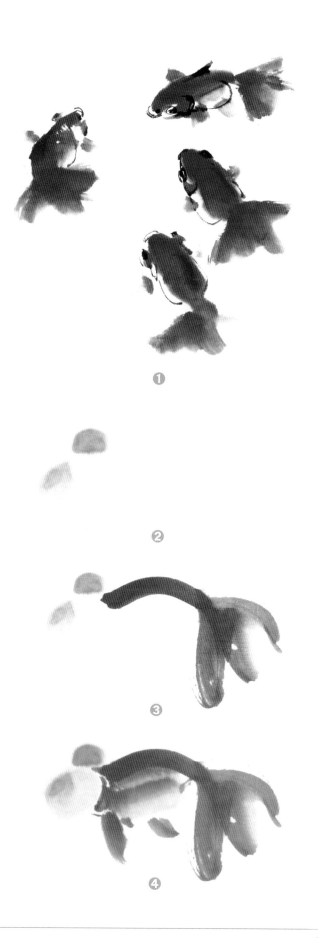

The brush is soaked with clear water to its base and tipped with orange red. The technique is otherwise similar to that for painting a black dragon-eyes goldfish (Cf. Figures 1-5 on page 38).

1. Dot the head and the eyes.

2. Starting from the rear of the head, move the brush in one stroke to the tail tip of the spinal ridge, and then paint the tail.

3. Make sure the caudal peduncle can be distinguished from the rest of the body; then paint the gills and the fins; line the eyes with gamboge.

4. Paint the mouth.

In the *xie yi* painting, there are a variety of ways to paint goldfish, all characterized by simple, fast strokes and accurate proportions (Fig. 1).

Painting the popular bubble-eye goldfish in the *xie yi* style

1. Paint the head and eyes of the bubble-eye goldfish in light orange red (Fig. 2).

2. Paint the spinal ridge (some exaggeration is fine), the caudal peduncle and the tail in deeper orange red (Fig. 3).

3. The belly should be in lighter shade and accurately proportioned; the mouth should be small and the eyes should be dotted with dark ink (Fig. 4).

Dragonfly

To paint this small insect, it is necessary to understand its anatomy.

As shown in the diagram (Fig. 1), the dragonfly has two button-like compound eyes (Fig. 2); its rectangular body is covered by fine stripes and it has a thin neck (Fig. 3). It has a pair of forewings and a pair of hindwings, with fine veins (Fig. 4). In flight it looks like a helicopter.

Painting dragonflies in the *xie yi* style

1. Dot the head and the pair of compound eyes with a brush tipped with orange red (Fig. 5).
2. Paint the body and the tail (Figures 6-7).

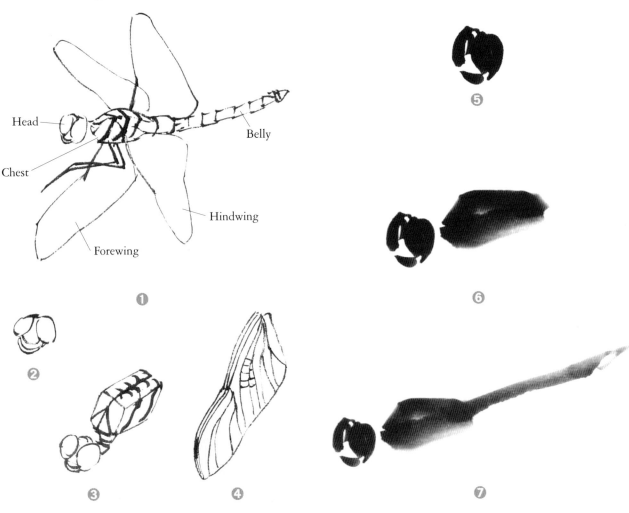

3. Paint the wings in pale red; before the color dries, outline the stripes, veins and the intersegmental annuli in ink (Figures 8-9).

4. Dot the costal margins (anterior edges of the wings); before the color dries, paint the veins by feather-edging, making sure they are fine and delicate, because the wings should look diaphanous (Fig. 10).

5. Outline the legs pointing forward (Fig. 11).

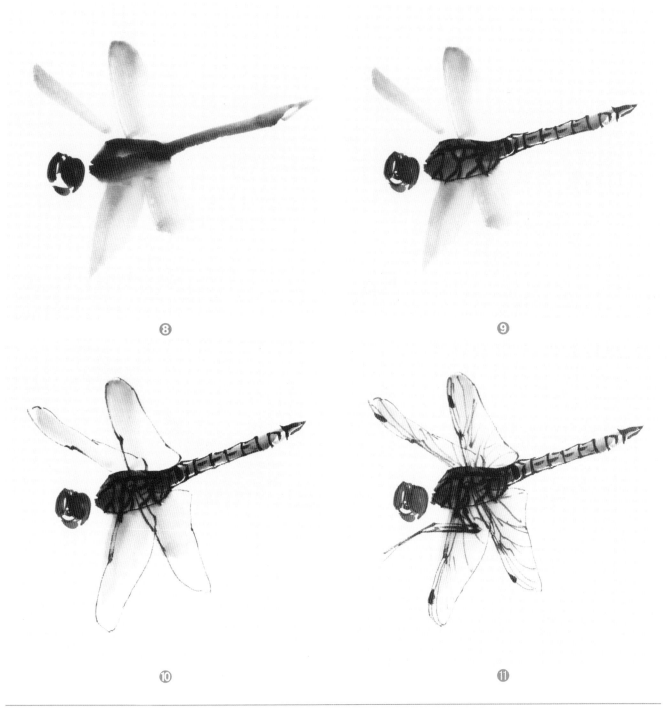

⑧

⑨

⑩

⑪

Examples of dragonflies in various colors and postures

The technique equally applies to the blue (use cyanine), green (use a mixture of gamboge and cyanine), red (use eosin), and yellow (use a mixture of gamboge and orange red) dragonflies (Figures 1-6).

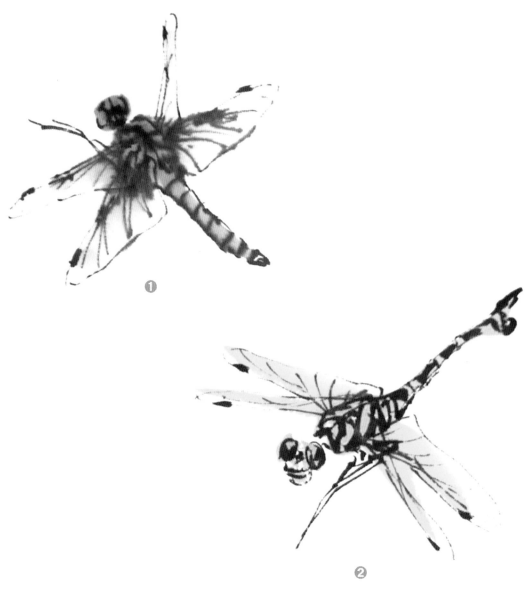

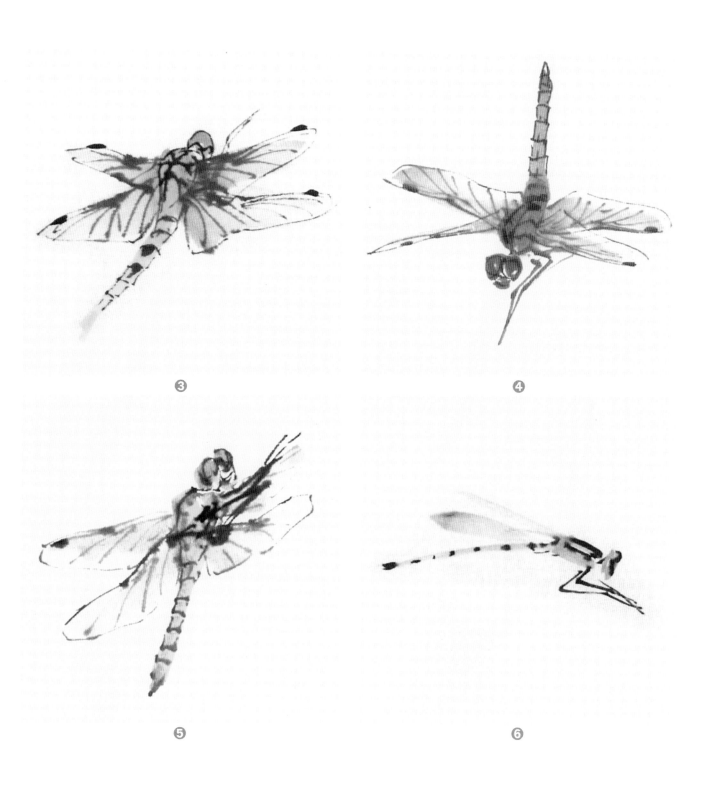

❸

❹

❺

❻

Example of "Young Lotus Leaflets Sticking Out Their Conic Heads" (Figures 1-7)

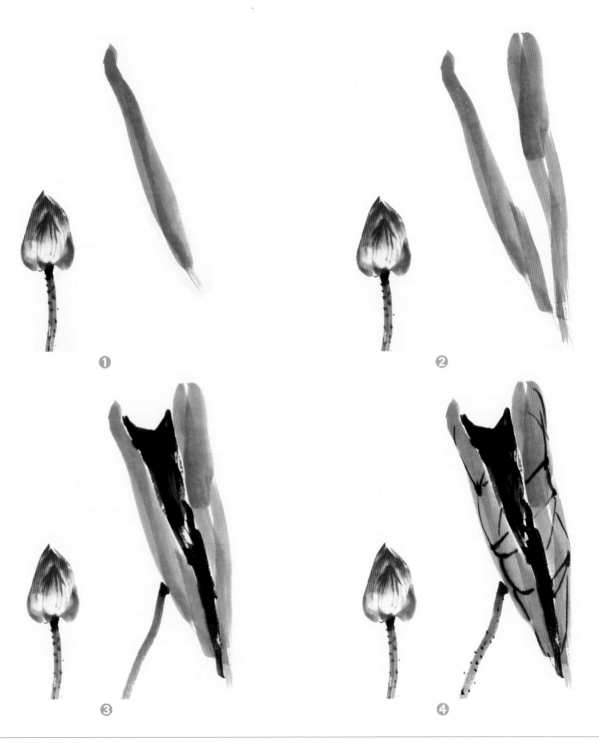

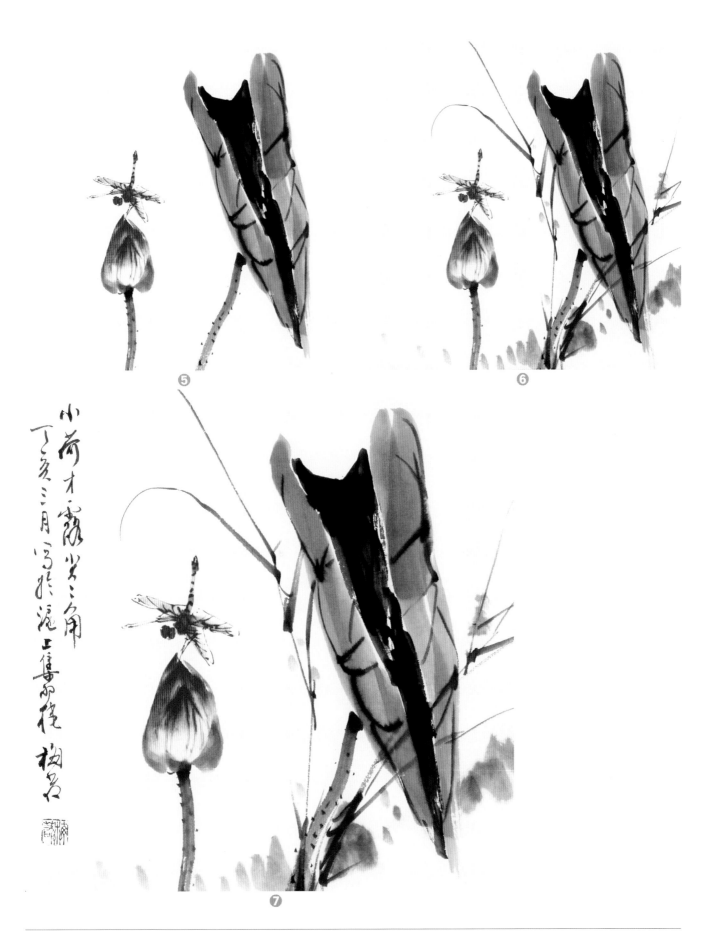

Butterfly

The butterfly is a common but beautiful insect, graceful in flight and appropriately called a "flying flower." An understanding of its anatomy will help the artist to make a good painting of the butterfly.

As shown in the diagram, the butterfly has symmetrical pairs of forewings and hindwings; the wings are covered by tubal veins and a wide variety of color patterns; the hindwings often end in a forked tail (Fig. 1).

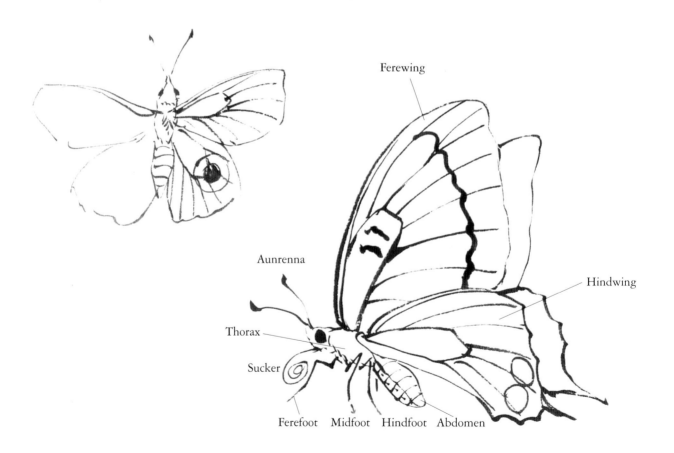

Ferewing

Hindwing

Aunrenna

Thorax

Sucker

Ferefoot Midfoot Hindfoot Abdomen

❶

46

Painting butterflies in the *xie yi* style

Method I

1. Paint the head, thorax and abdomen with a mixture of gamboge and ocher (Fig. 1).

2. Paint the wings at the thorax (Fig. 2).

3. Paint the eyes, antennae and abdominal segments in dark ink (Fig. 3).

4. Before the color dries, paint the color markings on the wings (Fig. 4); finally paint the legs (Fig. 5).

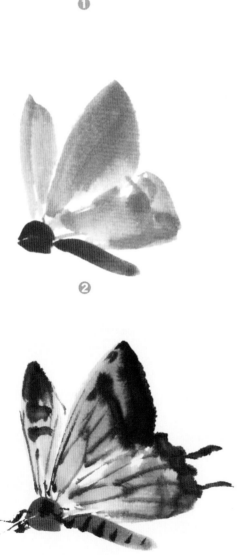

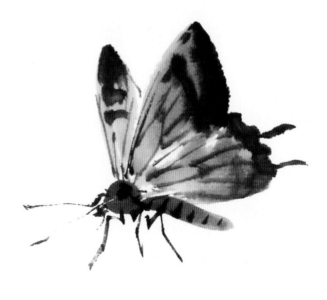

Method II

1. Paint the wings with a mixture of gamboge and orange red (Fig. 1).

2. If not satisfied with the result, add outlines to the edges of the wings; then paint the head and eyes; outline the veins on the wings in dark ink (Fig. 2).

3. Paint the antennae, abdominal segments and legs in ink (Fig. 3).

Method III

1. Outline the contours of the wings in ocher and cyanine (Fig. 4).

2. Paint the head, thorax and abdomen in ocher; paint the antennae and head in dark ink and dot the stripes (Fig. 5).

3. Before the color and ink dry, outline the tubal veins on the wings (Fig. 6).

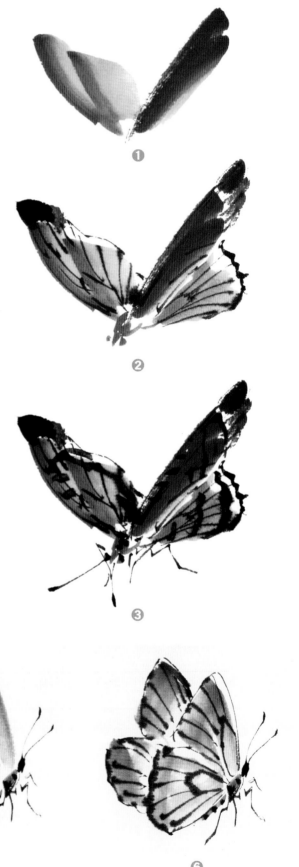

❶

❷

❸

❹

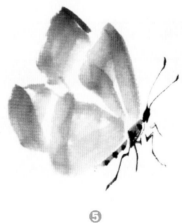

❺

❻

Examples of butterflies of various colors and stripes, and in different postures (Figures 1-4)

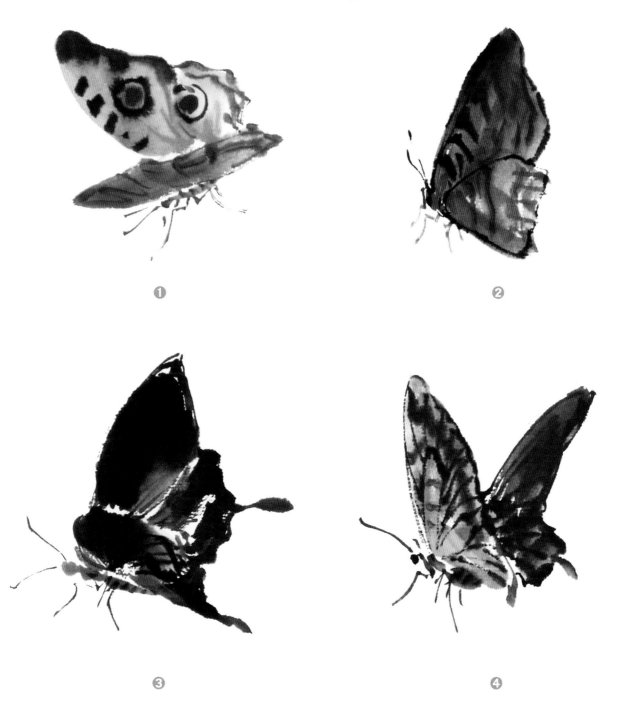

①

②

③

④

Example of painting a
butterfly (Figures 1-10)

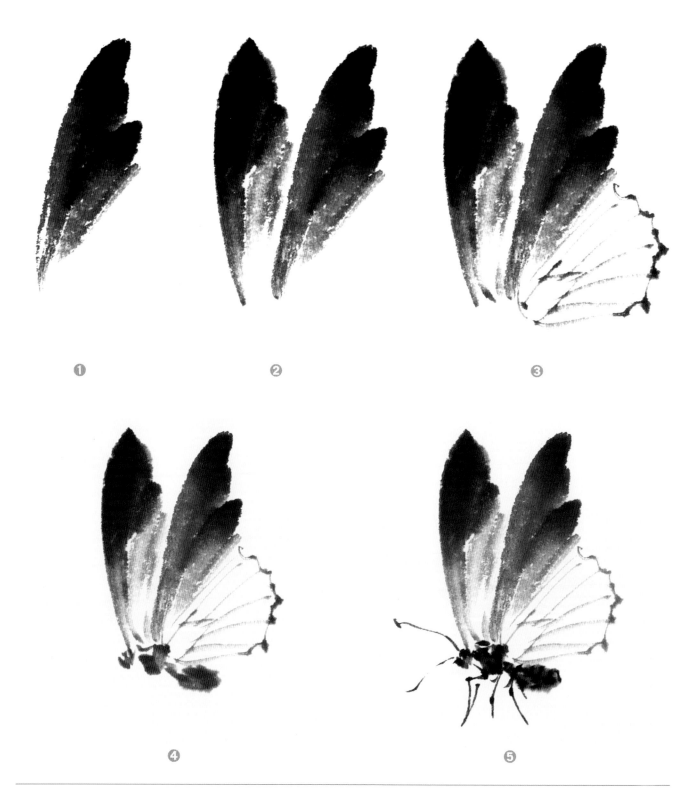

6

7

8

9

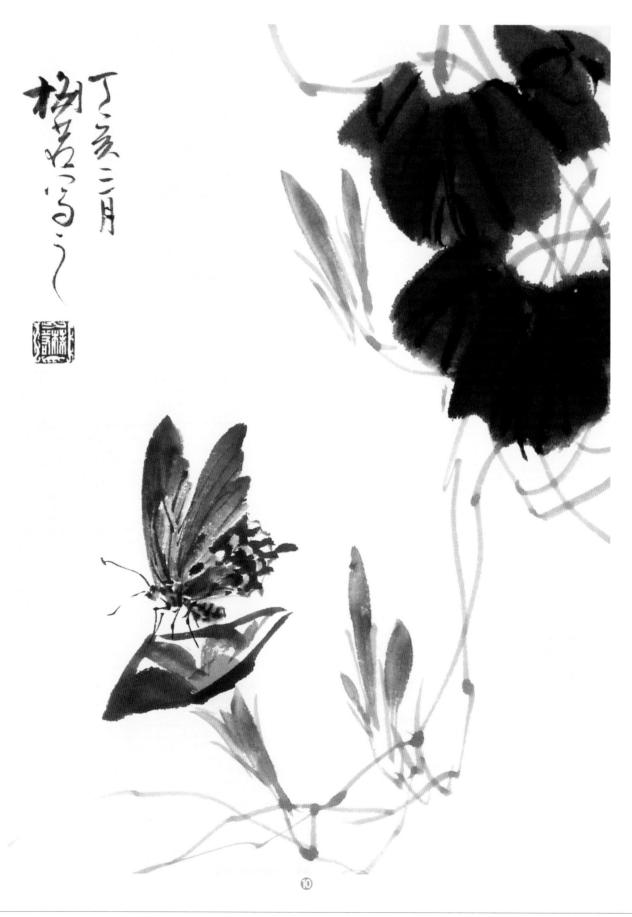

Appendices

Materials and Equipment for Chinese Painting

I. Brush

A Chinese painting brush can have soft or hard hairs or a combination of them. The brushes are made in large, medium and small sizes. The soft-hair brushes, generally of goat hairs, are very absorbent and suitable for dotting leaves and coloring. Wolf hairs make a hard brush that is tough and flexible and good for outlining leaf veins and tree trunks, among other uses. The combination brush is made of wolf and goat hairs.

The brush is composed of the tip, the "belly" (midsection), and the base (near the shaft).

II. Ink

Chinese painting is mainly done in ink, which is made from either lampblack or pine soot. Lampblack is darker, shinier and more suitable for painting. Pine soot is flatter and more suitable for calligraphy. In the past artists used to grind their ink sticks to make ink for their paintings; nowadays most artists prefer bottled ink. Choose the ink specially made for painting and calligraphy, otherwise the ink will fade after the painting is framed.

III. Paper

The paper used for Chinese painting is called *xuan* paper (also rice paper). There are two kinds of *xuan* paper: the mature *xuan* paper, which is treated with alum to make it less absorbent, good for the detailed style of Chinese painting because you can apply many coats of colors without fear of undesirable blending; and the raw *xuan* paper, which is untreated and absorbent, and suitable for the *xie yi* style because the blending of ink and color can be used by artists to produce nuanced ink tones.

IV. Inkstone

The inkstone used for Chinese painting is made from aqueous rock, which is hard and fine-textured and produces dense ink

when ground. The *Duan* inkstone, made from stone quarried in Duanxi in Guangdong Province, is the most famous of the inkstones in China. But people have turned to the more convenient bottled ink, which produces equally good results.

V. Pigments

The pigments used for Chinese painting are different from those used in western painting, and have different names. Pigments can be classified as water soluble, mineral or stone. Gamboge, cyanine, phthalocyanine, eosin and rouge are some of the water soluble paints; mineral paints include beryl blue, malachite, cinnabar and titanium white. Ocher comes under the "stone" rubric.

VI. Accessory equipment

Water bowl for rinsing brushes, felt table cover, palette etc.

Use of Ink and Brush in Chinese Painting

I. Using brush

Any stroke used in Chinese painting comprises three stages: entering the stroke, moving the brush along and exiting from the stroke. Some of the strokes are *zhong-feng* (centered-tip), *ce-feng* (side-brush), *shun-feng* ("slant-and-pull-away-from-brush-tip" or "downstream"), *ni-feng* ("slant-and-push-into-brush-tip" or "upstream"), *ti* (lift), *an* (press), *dun* (pause) and *cuo* (twist-around) etc.

The centered-tip stroke moves along the center of the ink line with the tip of the brush. To execute the side-brush stroke, the brush is held at an angle, with the tip against one side of the line (point or surface), and moves with its "belly" pressed against the paper (Fig. 1). The *shun-feng* stroke is used to paint from top downward or from left to right, while the *ni-feng* stroke moves from the bottom upward or from right to left (Fig. 2). "Lifting" the brush as it pulls along will make a lighter line. "Press" down on the brush to make a thicker and darker line. The *dun* stroke consists in pressing the brush into the paper or grinding and rotating the brush. Several *dun* strokes constitute a *cuo* stroke.

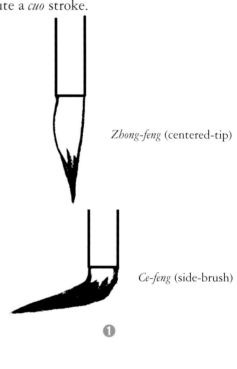

Zhong-feng (centered-tip)

Ce-feng (side-brush)

❶

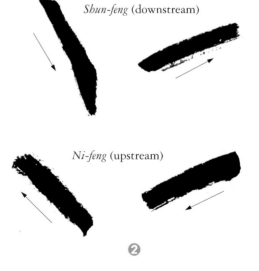

Shun-feng (downstream)

Ni-feng (upstream)

❷

II. Using ink

In Chinese painting it is important to master the use of the following five gradations of ink: dark, light, dry brush, wet brush and charred (burnt).

Dark ink: Add a small amount of water to the ink to make a dark shade;

Light ink: Increase the amount of water in the mixture to make a grayish ink;

Dry brush: A brush that contains only a small amount of water can apply either dark or light ink;

Wet brush: The brush contains more water and can also apply either dark or light ink;

Charred ink tone: Very black shading that creates a shiny black effect on the paper (Fig. 3).

the wetness or dryness of the brush to communicate the "spirit of the ink." The use of ink and the use of the brush are closely interdependent.

It is important to bear in mind these six words when using the brush: *qing* (light), *kuai* (fast), *ce* (side), *zhong*[1] (heavy), *man* (slow), *zhong*[2] (center).

Qing: Lifting the pressure on the brush while the stroke is in progress;

Kuai: Shortening the time of the stroke;

Ce: Using the *ce-feng* (side-brush) stroke;

Zhong[1]: Pressing down on the brush while the stroke is in progress;

Man: Increasing the time of the stroke;

Zhong[2]: Using the *zhong-feng* (centered-tip) stroke (Fig. 4).

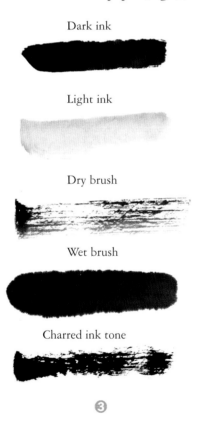

Dark ink

Light ink

Dry brush

Wet brush

Charred ink tone

❸

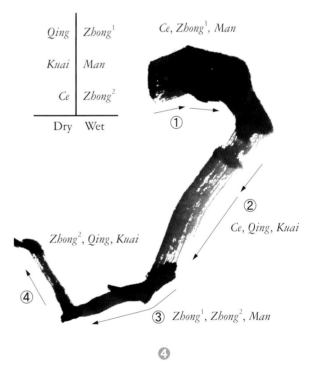

Qing	*Zhong*[1]
Kuai	*Man*
Ce	*Zhong*[2]
Dry	Wet

Ce, Zhong[1], *Man*

①

②

Ce, Qing, Kuai

Zhong[2], *Qing, Kuai*

④

③ *Zhong*[1], *Zhong*[2], *Man*

❹

III. Brush and ink

Brush and ink are mutually reinforcing. The use of ink is just the other side of the brush use.

The wetness or dryness of the ink translates into

It is common sense that when the brush has been soaked in water, whatever liquid in the brush will flow down faster when the brush is held upright but will run more slowly when the brush is held at a slant. In a centered-tip stroke the upright brush is pressed down and pulled at a more leisurely pace, the ink will consequently have ample time to be

absorbed by the paper and what results is a wet stroke. If the brush is held at an angle and is not pressed as hard against the paper and is pulled at a faster pace, there is less time for the paper to take in the ink; what results then is a "flying white" (broken ink wash effect), namely a dry stroke. It is therefore essential to learn how to properly manipulate the brush and ink.

IV. Different kinds of brush strokes and ink tones in the painting

The tree trunk sample offers an analysis of the different kinds of brush strokes and ink tones employed in the painting (Fig. 4) . This is a difficult example and it takes long practice to master enough skill to successfully execute it, because it requires the use of a combination of strokes such as the side-brush, flying white, the dry-brush, the centered-tip stroke and the wet-brush stroke, etc. Always pay attention to how you enter, execute and exit a stroke and remember the importance of variation in stroke speed, pressure, ink tone and wetness as well as balance in the use of strokes to compose a painting: stroke left before stroking right, stroke right before stroking left, stroke down before stroking up (Fig. 5) or stroke up before stroking down (Fig. 6).

Another technique used in Chinese painting is the *po mo* method (breaking the preceding application of ink), which consists of applying dark (light), wet ink over a preceding application of light (dark) ink before it dries. This method will impart a sense of lively variation and wetness to the painting. You can break light ink with dark ink or vice versa.

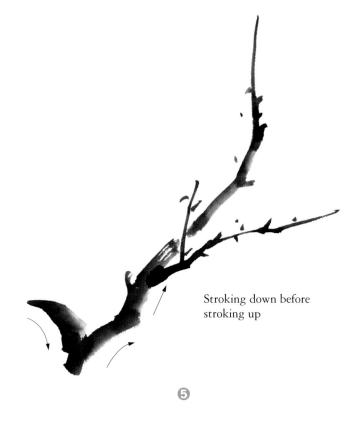

Stroking down before stroking up

⑤

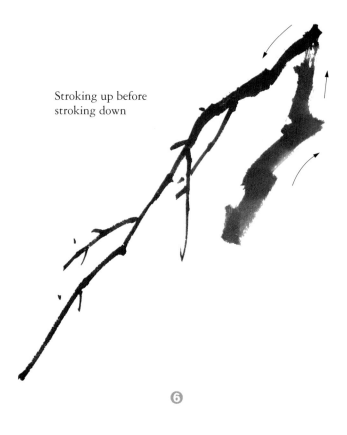

Stroking up before stroking down

⑥